First published in 2008 as Terry's Top Tips for Watercolour Artists

This edition published in 2018

Search Press Limited Wellwood, North Farm Road, Tunbridge Wells, Kent TN2 3DR

Reprinted 2020

Text copyright © Terry Harrison 2008, 2018

Photographs by Roddy Paine Photographic Studios Photographs and design copyright © Search Press Ltd, 2008, 2018

All rights reserved. No part of this book, text, photographs or illustrations may be reproduced or transmitted in any form or by any means by print, photoprint, microfilm, microfiche, photocopier, internet or in any way known or as yet unknown, or stored in a retrieval system, without written permission obtained beforehand from Search Press, Printed in China

ISBN: 978-1-78221-639-1

The Publishers and author can accept no responsibility for any consequences arising from the information, advice or instructions given in this publication.

Suppliers

If you have any difficulty obtaining any of the materials and equipment mentioned in this book, then please visit the Search Press website for details of suppliers: www.searchpress.com

Publishers' note

All the step-by-step photographs in this book feature the author, Terry Harrison, demonstrating how to paint with watercolours. No models have been used.

TERRY HARRISON'S

POCKET BOOK FOR WATERCOLOUR ARTISTS

TERRY HARRISON

CONTENTS

ABOUT THE AUTHOR 6

INTRODUCTION 8

WHAT TO BUY 10

COLOUR 22

USING PHOTOGRAPHS 24

MIXING WATERCOLOURS 26

WASHES 28

WET INTO WET 30

WET ON DRY 32

WATERCOLOUR PROBLEMS 34

MASKING 36

LIFTING OUT 40

PAINTING SKIES 42

PAINTING DISTANCE 46

PAINTING FIFL DS 48

PAINTING TREES 50

PAINTING GRASSES 54

PAINTING FLOWERS 56

PAINTING MOUNTAINS 62

PAINTING WATER 64

PAINTING BEACHES 72

PAINTING ROCKS 74

PAINTING CLIFFS 75

PAINTING BOATS 76

PAINTING ROOFS 77

PAINTING WALLS 80

PAINTING WINDOWS 84

PAINTING DOORS 86

STILES, GATES AND FENCES 88

WINTER SCENES 90

ADDING LIFE 94

INDEX 96

ABOUT THE AUTHOR

Terry Harrison grew up in Norfolk. His early art education was basic and he never dreamed that he would become an artist. At fifteen, Terry moved to Hampshire and was inspired by a brilliant art teacher. He took O- and A-levels in art, then won a place at Farnham Art School at the age of sixteen. He became a graphic artist, but continued to paint in his spare time. In 1984 Terry gave up his job to paint full time and never looked back, teaching and demonstrating his watercolour techniques throughout the world, developing his own range of brushes and paints and writing over twenty best-selling books that have been translated into many languages.

Sadly, Terry passed away in 2017 but his legacy lives on. His gift for explaining his methods in an easy and accessible way has encouraged countless people to take up painting, and his beautiful works of art, inspired by the English countryside that he loved, will continue to be enjoyed by people all over the world.

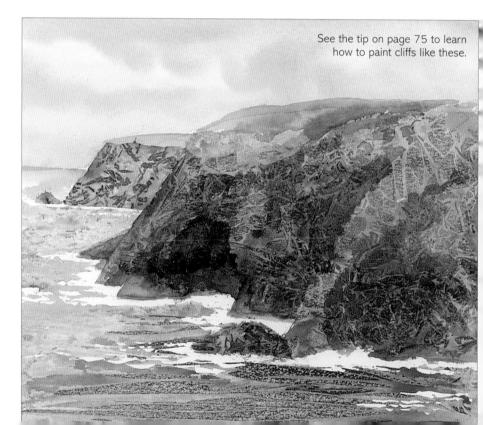

INTRODUCTION

My aim in teaching art has always been to make painting more accessible by helping to make the techniques easier. I have even created my own range of brushes, specially designed to make it easier for the beginner to achieve a variety of effects.

Much of my advice on watercolour techniques is based on common sense: for instance, to achieve wet into wet effects, the paper surface has to be wet, not merely damp or beginning to dry! Years of experience of painting and teaching have meant that I have accumulated a wealth of handy tips for successful painting, and they are all gathered together in this book to take the mystery out of watercolour techniques.

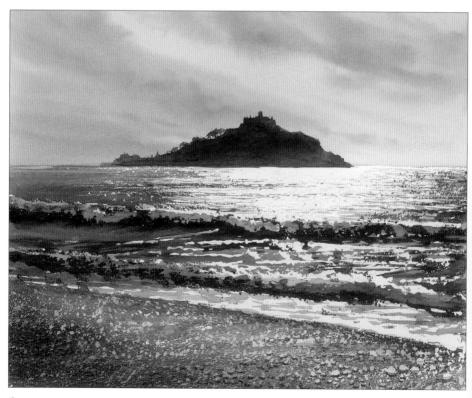

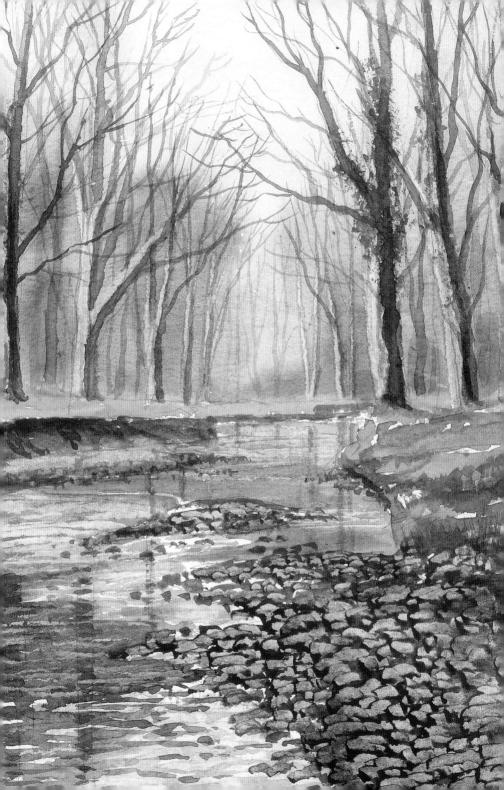

Paper

Whatever paper you start painting on will probably be the paper you stay with. The reason for this is that you learn how to paint on a certain surface, and if you change to another surface, you need to adapt your style. For instance, if you paint a wash, it will work perfectly on one surface but will not be right on another. All the paper used in this book is Bockingford, a wood pulp paper which is not too absorbent and is a good surface for masking fluid. It is white as opposed to cream and it is an inexpensive, good-quality paper.

You can also buy tinted papers in colours such as grey, pale blue, cream and oatmeal. By choosing a coloured background to your painting, you can enhance the mood; for instance, a blue or grey might be good for a winter scene, whereas a sunset might require a warmer tint such as cream or oatmeal.

Choosing the right paper

Watercolour paper comes in three surfaces, Hot Pressed (smooth), Not (called this because it is not hot pressed; it is in fact cold pressed) and Rough. The hot pressed paper shown on the right is suitable for botanical and detailed paintings, portraiture and fine detail.

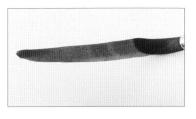

Rough paper is an ideal surface for landscapes and seascapes, as the surface helps give the impression of texture and is particularly useful for the dry brush technique.

How to avoid paper cockling

Cockling occurs when you apply a wash to the paper surface. The fibres in the paper soak up the water and expand. If the paper is unevenly wetted, the fibres expand at different rates and cockling occurs. This is why artists are recommended to stretch paper by soaking it, taping it to a drawing board and allowing it to dry. The paper shrinks as it dries, but because it is taped at the edges, it dries fully stretched. I find, however, that although the paper dries almost flat, some cockling will still occur when you apply washes. I also find that stretching paper affects the paper, as some of the size is removed. For these reasons I don't bother to stretch paper.

The simplest way to flatten a painting that has cockled is to turn it face down, wet the back of it (don't over-wet it), allow the water to soak in, and when the paper is fully expanded, put a drawing board over it and weigh it down with a pile of books. Let the painting dry overnight and it will dry completely flat.

The other solution to cockling is to use a heavy paper. I use a 300gsm (140lb) paper, but to avoid cockling altogether, use an even heavier paper.

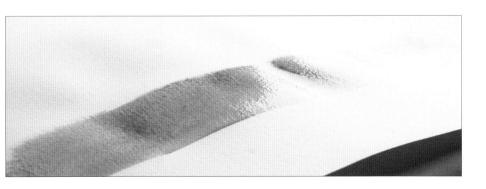

Brushes

Many artists adapt standard watercolour brushes to suit their needs. I have gone one step further and created my own range of brushes, designed to help you achieve the best effects with the minimum effort. You can of course choose brushes from other ranges; look for the attributes described below.

Use brushes fit for purpose

Shown opposite from top to bottom are the brushes you will need to create the effects shown in this book. The brushes also come in 'px' versions, which have a clear acrylic resin handle with the end shaped specially for scraping out techniques.

The **half-rigger** has long hair with a very fine point. It holds quite a lot of paint and is ideal for adding very fine details wet on dry. It is good for painting grasses and flower stalks.

The **small detail brush** is the smallest of the round brushes in my range. It is good for painting fine details.

The **medium detail brush** is the workhorse of the range, the one you reach for most often. It holds quite a lot of paint but still goes to a fine point, and is good for painting any but the finest details.

The **large detail brush** holds a lot of paint, so is ideal for washes, yet it goes to guite a fine point, making it very versatile.

The **fan stippler** is good for painting trees with a stippling technique. The blend of hair and bristle creates a range of textural effects that can be used to mimic elements of nature such as leaves.

The **foliage brush** is excellent for producing leafy effects and it can also be used for texture on buildings, footpaths and walls.

The **19mm (¾in) flat brush** is useful for washes and for painting water. It can be used with a side-to-side motion to create horizontal lines such as ripples on water.

The **wizard** is made from a blend of natural hair, twenty per cent of which is slightly longer than the rest and forms small points. It is good for grasses and reflections.

The **golden leaf brush** holds lots of paint, so is ideal for sky washes or for water. It is good for stippling trees and foliage and for painting texture.

The **fan gogh** is thicker than most fan brushes and holds plenty of paint. It is good for trees, grasses and reflections in water.

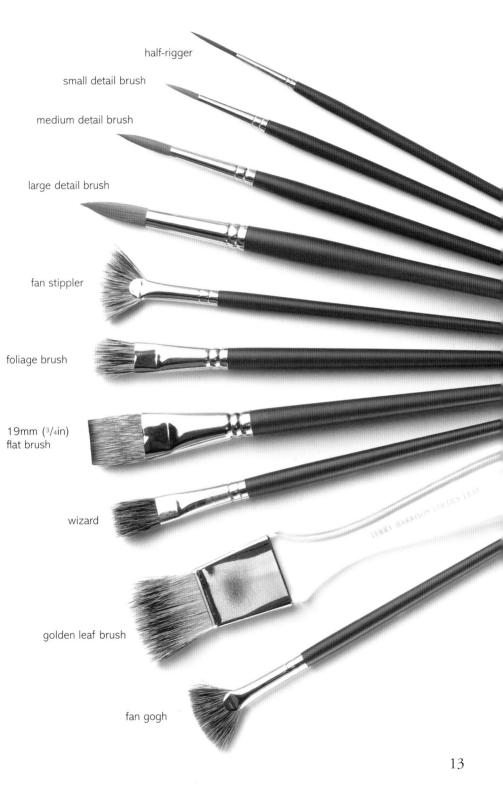

Washing your brushes well

In my studio I use a bucket to wash out my brushes. This is because the more water you use, the cleaner your brushes become. There is little point in trying to clean your brushes in a small jam jar. Also, the water stays cleaner for longer.

The alternative is to use two water pots, one for washing your brushes and the second for mixing your colours with clean water.

When painting on location, I carry my paints in an ice cream tub. I tip the paints out on arrival and fill the ice cream tub with water. I use water from a nearby river, stream, water fountain or café.

Never leave brushes standing in water, as this will bend the tip of the brush, and the water will soak up into the wooden handle. The wood then expands and the paint on the handle cracks and peels off.

Storing your brushes

I carry my brushes in a folding brush case with a zip. You open the case and all your brushes are in front of you, ready to use. What could be simpler?

A brush roll can crush brushes such as fan brushes and flats. I certainly would not recommend storing brushes in a tube. If you store wet brushes in a tube and it is held upside down, the bristles will bend, and when dry they can remain bent.

At the end of a painting session, run the brushes under a tap, pat them dry with kitchen paper, reshape them if necessary and return them to your brush case ready to paint your next masterpiece.

Paints

Watercolour paints come either in pans or in tubes. As with paper, people tend to stick with whatever they started with. Generally, tube colours are suitable for studio work, as you are likely to paint on a larger scale, and will use bigger brushes which do not fit into pans. When you are painting outside, you might find a compact set of pans more convenient and easier to carry.

outside, you might find a compact set of pans more You can buy either student quality or artist quality watercolour paints. I would recommend that you start with artist quality as they have a higher pigment content, in other words there is more colour and less filling. BLANCPERMANENT

Choosing the right paint

If you are painting large washes, it is best to use tube colours in artist quality. If you use student colours, you use a lot of paint to achieve the same colour, so the money you save on buying the cheaper paint turns out to be a false economy.

Choosing colours

Shown below is my basic palette of colours. I have found over the years that I can mix most of the colours I need from these twelve. The range includes my own ready-made greens, sunlit green, country olive and midnight green (see page 23).

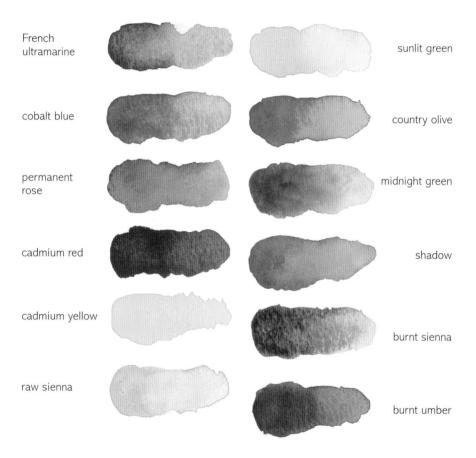

Laying out your colours

Personally I prefer to use tube colours, and I position them in my palette in groups; greens at one end, earth colours in the centre and blues at the other end.

Mixing colours first

Always mix colours in your palette before applying paint to your painting, so that you can check the colour and paint consistency first. Never apply neat paint straight on to your painting.

Other materials

A hairdryer This is used to speed up drying times to stop you from overpainting on a wet surface.

Ruling pen

Sometimes called a bow pen or a drawing office pen, this is used for applying masking fluid, as the fluid does not stick to the metal. It is ideal for masking out grasses or, with the aid of a straight edge, long straight lines. You can also use it to apply paint or ink to a painting.

Kitchen paper

This is ideal for removing excess water from your paint brushes. You can use it for lifting out colour from a painting. It can be used to mop up puddles of watercolour on a painting, helping to prevent 'cauliflowers'. It is also useful for cleaning out your palette.

Eraser

Ideal for enhancing your drawing rather than correcting mistakes! Before painting, it is always a good idea to remove excess pencil marks. I use a hard eraser rather than a putty eraser, because a putty eraser tends to smudge the pencil line rather than removing it.

Soap

This is applied to a brush before using masking fluid. This forms a barrier between the hairs of the brush and the masking fluid and makes cleaning the brush much easier.

Pencil

I use a 2B pencil for drawing as it gives you the option of achieving dark or light tones and is easy to erase.

Masking fluid

This is a liquid latex which, when applied to paper, dries quickly and creates a resist. You can then paint over it, and when the paint is dry, you can remove the masking fluid by rubbing it with your fingers, to reveal white paper underneath.

Pencil sharpener

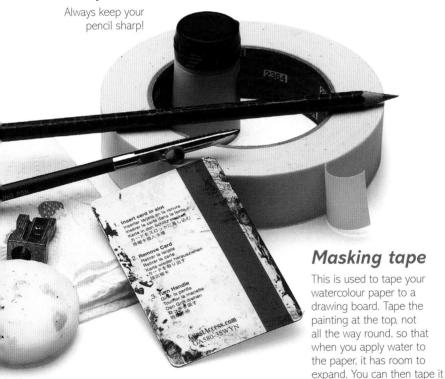

Plastic card

This can be used to great effect for creating texture on tree trunks, rocks, cliffs and mountains.

at the bottom while it is wet.

COLOUR

The basic colour range I use is listed on page 18. In addition to my standard palette, I use other stronger, brighter colours such as turquoise, which are ideal for painting flowers. You can mix secondary colours from a basic range of colours.

You often hear the expression 'never use black'. There is a reason for this: black tends to dominate a painting and is a dull, dead colour. You can mix the dark colours you need from your basic range of colours, and by varying the mixes you can create interesting rather than dead colours.

Mixing greys

Greys can also be mixed from your basic range of colours as shown here.

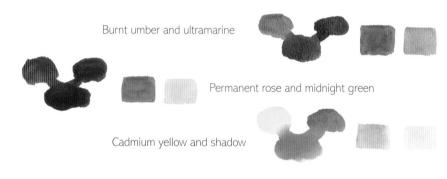

Two-colour study

This simple painting was achieved using just two colours: permanent rose and midnight green.

Using ready-made greens

To mix a successful green, you would need at least two or three different colours. There is a general rule in watercolour painting that if you mix three or four colours, the painting becomes muddy. If you buy a ready-made green, it is a fresher colour and you can treat it as one colour, and add a second and a third colour without the result becoming muddy.

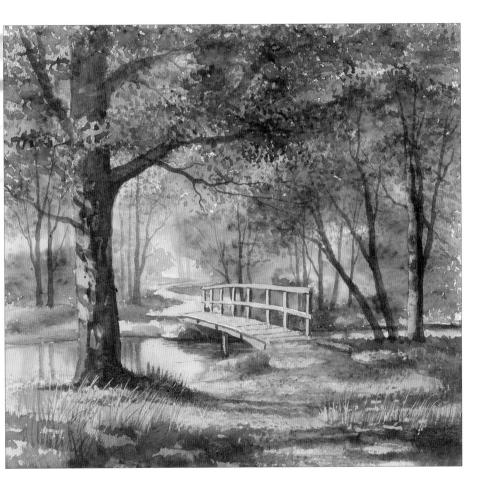

USING PHOTOGRAPHS

There is nothing wrong with using photographs as reference for a painting. Most artists use photographic reference as an aid. The key to it is to use photographs as a reference rather than copying the image exactly. It is very difficult to achieve the perfection of the photograph, but using it as reference, you can alter the view to achieve an almost perfect painting.

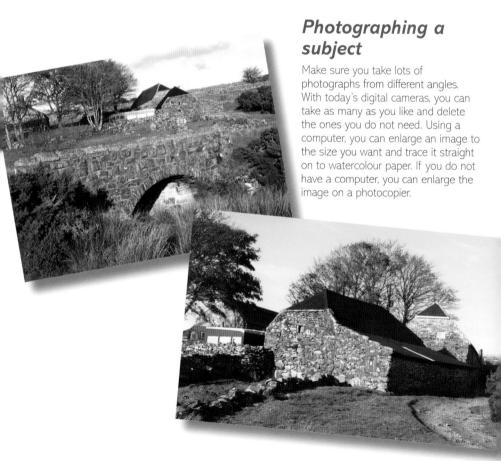

Painting from photographic reference

The painting below was composed from the two photographs shown opposite, selected from around twenty shots of the same scene. As you can see, I have used one photograph as a reference for the bridge, and the other as a reference for the buildings. Combining the two elements, you can create a painting of the scene which is not factually accurate but makes for a more pleasing composition.

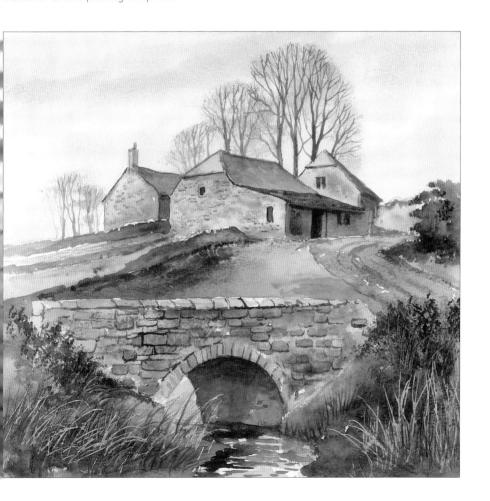

MIXING WATERCOLOURS

Paint consistency seems to be the biggest hurdle to overcome when you are starting to paint in watercolour. There is no magic formula for getting this right; it comes with experience. It is worth taking the time to practise and experiment with different mixes.

Add paint to water, not water to paint

If you add water to the paint in your palette, you can end up with a very watery mix. If you then need a stronger mix, you will need to start again. Instead, follow the steps shown here.

 Put a damp brush into neat paint and place it in the palette.

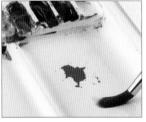

3. Wash the brush and place a little clean water on a clean part of the palette.

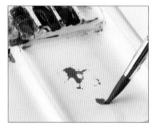

4. Now pick up a little of the neat paint and add it to the water to make a weaker mix.

5. Now the brush will make a paler mark.

You can repeat this process several times, and you will end up with several different options in your palette, from the original strong mix to various weaker tints.

Dry your brush on kitchen paper

Sometimes a paint mix seems right in the palette, but when you apply it to the paper, it is too wet to create the type of effect you want. In most cases, the brush is simply overloaded.

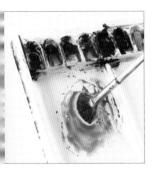

1. Here I make a strong mix of green in the palette, which I want to use with my fan qogh brush to paint grasses.

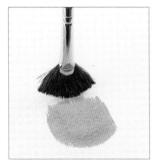

2. When I attempt to flick up the brush to create the effect of grasses, the paint is too wet and fills in the shape.

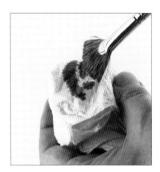

3. Instead of starting again, I remove excess wet paint from the brush by dabbing it on kitchen paper.

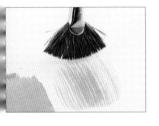

4. The grass effect works perfectly with the drier brush.

Try the mix out first

Before using a paint mix in your painting, always try it out first on scrap paper or at the edge of the painting, to see what kind of mark it makes.

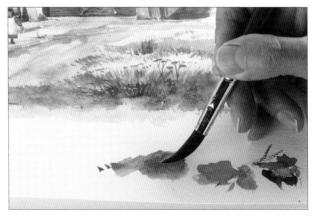

WASHES

Painting a wash might seem simple, as it generally involves just one colour and a big brush, but it can easily go wrong if you use the wrong paint consistency or an unsuitable brush.

Applying a flat wash

Always mix enough colour so that you do not need to mix more while painting, as a flat wash needs to be applied quickly and smoothly. The painting board should slope down towards you so that the paint will run down slightly to create a bead at the bottom.

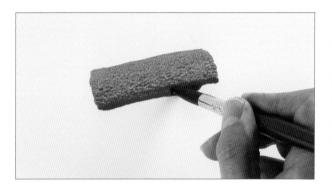

1. Take a large wash brush such as the large detail brush, as this holds plenty of paint. Paint in horizontal strokes, each one lower than the one before it. With each stroke, pick up the bead of paint that forms at the bottom of the wash and use it to paint the next stroke.

2. Continue extending the wash downwards as shown. Pick up more of the mix from the palette as needed. At the bottom of the wash, use the brush to pick up and remove the bead of paint.

Applying a graded wash

A graded wash starts with a strong colour at the top and fades to a paler tint further down as more water is added. The painting board should slope down towards you.

1. Pick up the paint mix from the palette with a arge wash brush. Paint in norizontal strokes from the top downwards. A bead of paint should form at the pottom of the wash.

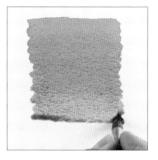

2. Pick up clean water and mix it into the colour on the palette. Feed this into the bead at the bottom of the wash as you paint the next stroke.

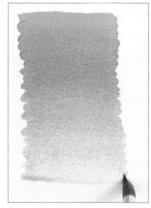

3. Continue adding water. At the bottom of the wash, pick up the bead.

Applying a variegated wash

A variegated wash starts with one colour and merges into another. It should be left to dry on a slope, as it was painted. This allows the colours to continue merging.

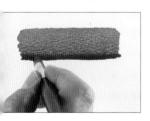

1. Start with one colour.

Make sure there is an even bead at the bottom.

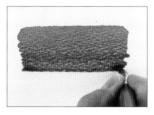

2. Clean the brush, pick up the second colour and merge it into the bead. The second colour merges into the first as you continue to paint horizontal strokes down the paper.

3. Wash the brush again and pick up the clean second colour from the palette so that the second colour appears unmixed at the bottom of the wash.

WET INTO WET

To achieve this technique, both washes must be wet. If you are applying wet paint into a semiwet background, the paint you are applying will not flow smoothly into the first colour, but will create unwanted effects such as 'cauliflowers' or 'bleedbacks' (see page 34).

Dropping in a second colour

It may sound obvious, but make sure the first colour is still wet on the paper when you drop in the second.

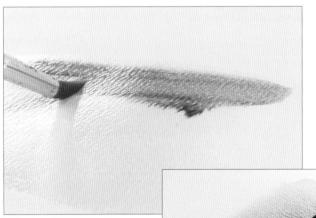

1. Wet the paper first. This slows down the drying time of the first colour so that you have plenty of time to work before the paint dries. Paint on the first colour, here a sky blue.

2. Pick up the second colour and dab it on to the paper on top of the first. The second colour spreads into the first, creating a soft, cloud-like effect.

Wet into wet rainclouds

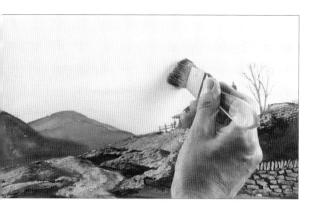

1. Use a large brush such as the golden leaf brush to paint a thin wash of raw sienna across the whole sky area.

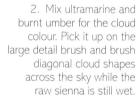

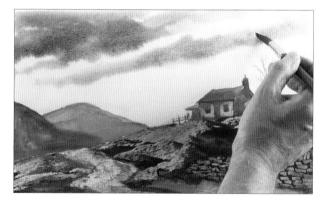

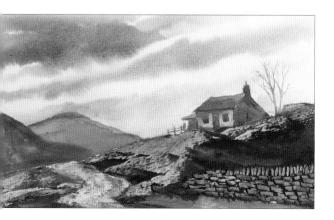

3. Allow the painting to dry naturally. The clouds will continue softening into the background sky colour as the paint dries.

WET ON DRY

This technique is suitable for adding detail to a painting. If the background colour is still wet, the colour you are adding will bleed into it, creating unwanted wet into wet effects.

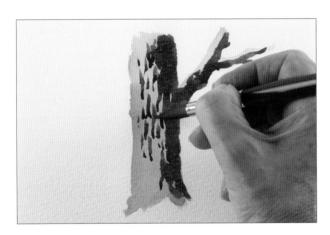

Painting wet on dry

If you allow the background colour to dry thoroughly before applying a second colour, the paint will make clear, hard lines instead of spreading and merging as in the wet into wet technique.

The dry brush technique

This technique can be used to create interesting textures. The paint is picked up on a 'thirsty' brush which is only slightly damp, not wet. The brush is dragged across the surface of Rough paper, where it leaves a speckled effect. You need to keep using kitchen paper to soak up the excess water from the brush as you paint.

1. Paint the tree trunk with an initial wash, and allow it to dry. Wash the brush with clean water, then dab it on kitchen paper to soak up the excess water.

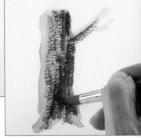

2. Load the brush with the second colour and drag it over the surface of the paper on top of the dried wash, to create a speckled effect. You can then darken the shaded side further.

Glazing

ilazing is applying a wash of colour over whole areas of a dried painting. The wash must be thin enough to be ransparent. This woodland scene was painted in grey and brown tones, and then glazed with bright colours to reate a sunset.

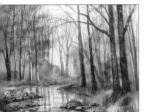

he original painting.

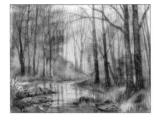

1. Clean water was brushed over the whole painting. I then used the golden leaf brush to paint on a wash of cadmium yellow in the sky and its reflection in the water.

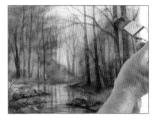

2. I then added a wash of permanent rose and cadmium yellow wet into wet.

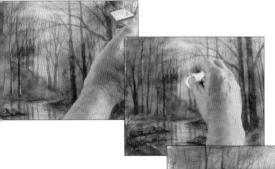

3. I added a glaze of permanent rose at the top of the sky and in the water, then I lifted out a bright patch in the sky using kitchen paper.

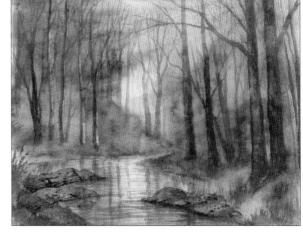

The finished, glazed painting.

WATERCOLOUR PROBLEMS

Unwanted hard lines such as bleedbacks, cauliflowers, backruns and tide lines – call them what you like, they are still a pain. The trick is to know why they happen so you don't make the same mistakes again.

Avoiding hard lines

Unwanted hard lines occur if you are attempting a wet into wet effect, but the first wash dries as you are applying the second. The darker cloud colour shown here should have spread softly into the background, but it has dried in unconvincing hard lines. To avoid this, always work while the paint is still wet.

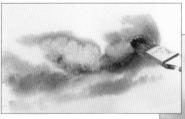

A cauliflower effect is created if you drop a thinner wash on top of thicker wet paint, as shown here. To avoid this, when working wet into wet, make sure each subsequent paint mix is thicker than the one before it.

Avoiding the cauliflower effect

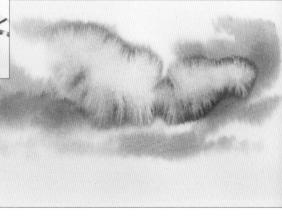

Repairing unwanted hard lines

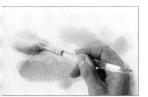

1. Wait until the painting is thoroughly dry. Wet the area that needs repairing and beyond it, so that any paint that you disturb will flow into the wet area.

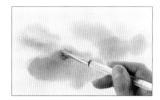

2. Use the brush to scrub gently around the hard line to remove it.

3. Now you can complete the painting of the clouds, working wet into wet. Drop in a mix of ultramarine and burnt umber while the paper is still wet.

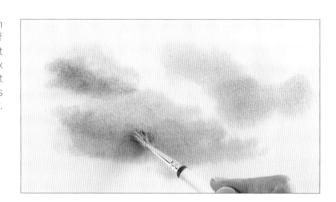

Repairing cauliflowers

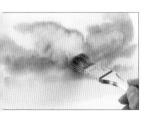

I. When the painting is dry, wet the whole area with clean water. Use he golden leaf brush to agitate the edges of the cloud where it has dried ato a cauliflower effect.

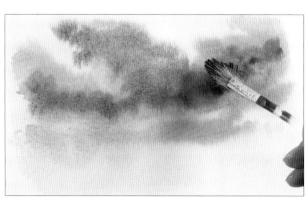

2. While the painting is still wet, drop in the ultramarine and burnt umber mix to create dark clouds.

Masking

Masking is all about keeping certain parts of the paper white, allowing you to paint freely over the masked area.

Do not use masking fluid on damp paper, as it soaks into the paper and dries, so that when you remove it, it tears the paper surface.

Do not leave masking fluid on for longer than two or three days, as it becomes too hard and is difficult to remove. The same thing can happen if you dry the masking fluid with a hairdryer.

How to protect your brush

Masking fluid can ruin your good brushes. To avoid this, wet the brush and rub it in ordinary soap before dipping it in the masking fluid. The masking fluid will then wash out easily when you have finished using it. If masking fluid dries on your brush, washing with soap simply will not remove it, but you can clean the brush with lighter fluid.

How to apply masking fluid with a brush

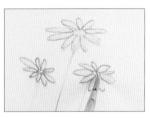

1. Brush on the masking fluid where you want the paper to stay white.

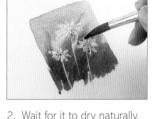

Wait for it to dry naturally, then paint your colours over the top.

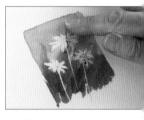

3. Allow the paints to dry, then rub off the masking fluid with a clean finger.

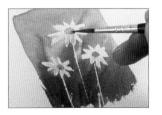

4. You can then paint another colour on to the white areas. I have added pale ultramarine shading and cadmium yellow centres to these daisies.

Using a ruling pen

When using a ruling pen, do not have the gap in the nib too vide, or the masking fluid will come out in blobs.

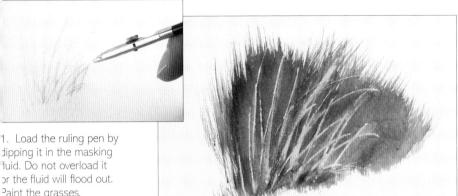

dipping it in the masking fuid. Do not overload it or the fluid will flood out. Paint the grasses.

2. When the masking fluid is dry, flick up grasses using the first green mix. Allow to dry, then rub off the masking fluid. You can now apply a lighter green mix and some yellow to the white areas.

Using the edge of a piece of card

- 1. Dip the edge of the piece of card in a saucer of masking fluid. Apply it to the paper as shown to create a fence.
 - 2. Allow the masking fluid to dry and then proceed with your painting. When the painting is dry, remove the masking fluid. You can now add a wash to the white areas.

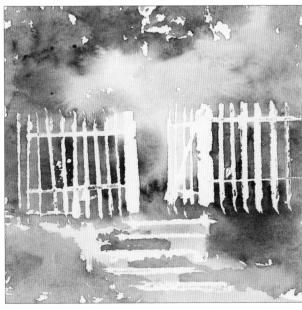

Using a sponge

You can use a synthetic sponge but the best ones for creating texture are the natural ones, as synthetic sponges are often too smooth.

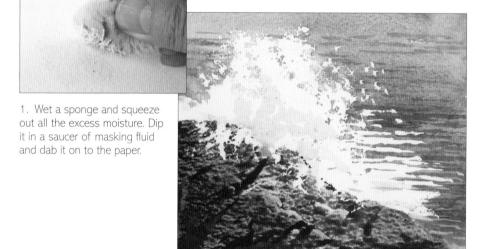

2. Once the masking fluid is dry, paint the sea and the rocks. When the paint is dry, rub off the masking fluid to reveal the white spray area. You can shade this with a little cobalt blue.

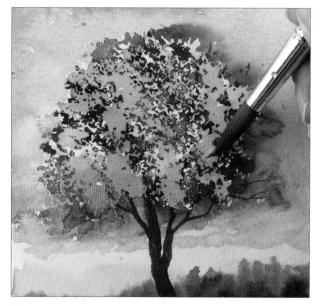

The blossom on this tree was also created using masking fluid applied with a sponge. I then rubbed off the masking fluid and applied a wash of permanent rose to the white parts.

Using a paper mask to paint hedgerows

1. Take a piece of magazine type paper (glossy, coated paper) with a straight edge and hold it firmly on your watercolour paper. Paint a nedgerow and bushes just above the paper mask as shown.

2. Carefully move the mask and change the angle, then paint another hedgerow coming further forwards. Continue in this way.

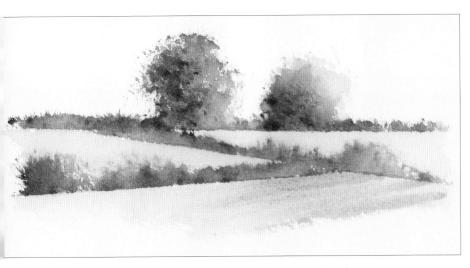

3. Fill in the fields between the hedgerows with different colours, making the colours warmer as they come further forwards, to create the effect of a patchwork of fields stretching into the distance.

LIFTING OUT

Because watercolour is water soluble, you can rewet the paint and remove it in many different ways, for example with a sponge, kitchen paper or a damp brush. Be cautious, as some paints are staining colours and are more difficult to remove. To be on the safe side, practise lifting out paint on a separate piece of paper.

Using kitchen paper

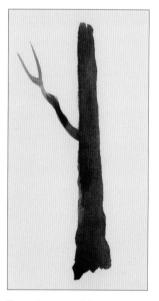

Sometimes an object you have painted comes out too dark; for instance, a tree can look too dominant and too far forwards.

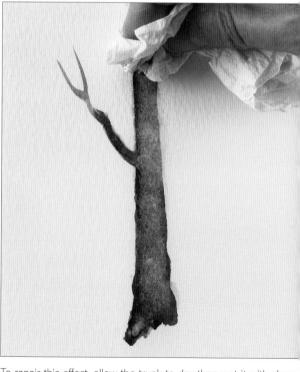

To repair this effect, allow the trunk to dry, then wet it with clean water on a brush to loosen the colour. Blot the wet trunk with kitchen paper to lift out colour.

Using a brush with a paper mask

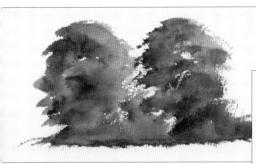

1. Paint tree shapes down to the ground and leave to dry. Take a stiff bristle brush, wet it and dab it on kitchen paper. Use it along the edge of a paper mask to lift out a trunk shape.

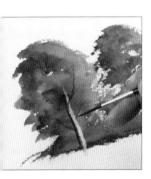

2. Take a thin brush such as a half-rigger and paint a shadow down one side of the trunk, and branches.

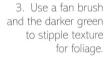

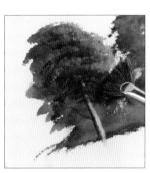

Using a damp brush

Allow the painting to dry. Wet a flat brush and remove excess water on kitchen paper. Now use the straight line of the brush end to lift out a trunk and branches from the painted foliage background. You can go on to add shade as with the other tree.

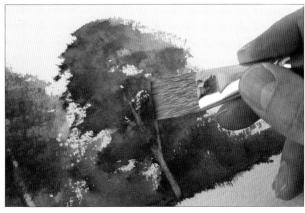

PAINTING SKIES

The general rule when painting landscapes is to paint the sky first. I know I hate rules, but this is a good one! You build a painting from the back to the front, so the order is sky, far distance, middle distance and then foreground.

I use two blues when painting skies: ultramarine and cobalt blue. I tend to use cobalt blue for mediterranean skies, and ultramarine when painting most other skies.

A wet into wet sky

A sunset is a good example of a variegated wash. The sky and the background of this painting were painted wet into wet, then allowed to dry. The trees and details were painted on to the dried surface. The sunset is cadmium yellow with cadmium red on the horizon and permanent rose above this, fading into cobalt blue to create a purple.

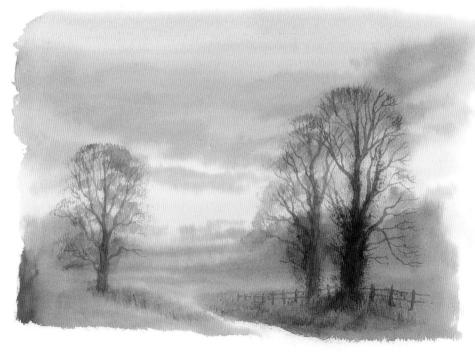

Painting clouds

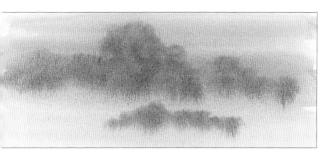

1. Paint the sky wash and while it is wet, drop in a dark mix of burnt umber and ultramarine to create cloud shapes.

2. Before the clouds dry, use kitchen paper to lift out lighter areas at the tops of the clouds, creating highlights.

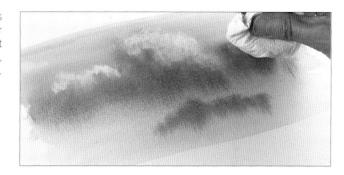

The finished sky.

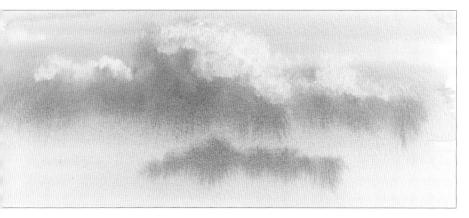

Tilting the board to make colour run for rain

To succeed with this effect, you need to have plenty of paint ready mixed in your palette. The first colour is applied to a wet surface, then the second colour is added. Tilt the board diagonally and let the second colour run. When the right effect is achieved, let the painting dry on a slight slope, not flat or the paint might run back.

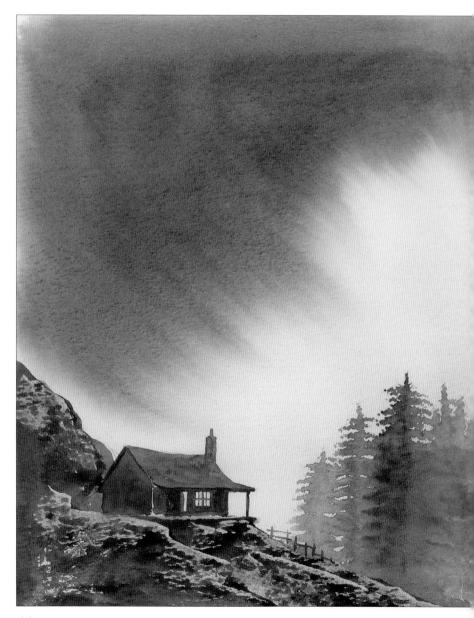

Lifting out the sun with a coin

Do not mix the yellow too strong when painting a sunset; you need to start with a pale, translucent colour, not a thick, opaque one. Choose a zoin that is the right size for the sun in your painting.

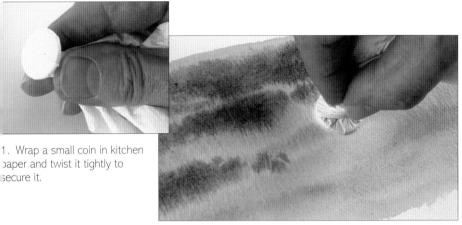

2. Paint your sunset, and while the paint is wet, firmly press down the paper-covered coin.

3. Lift up the coin to reveal the sun shape.

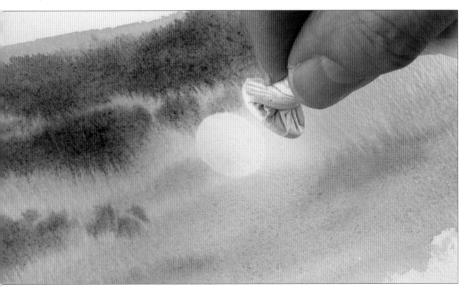

PAINTING DISTANCE

To create distance in a painting, you need to dilute your colours to make them paler, and also make them bluer or cooler.

Using colour to create aerial perspective

In this example, I have used a pale wash of ultramarine blue for the far distant hill, then a warmer mix of ultramarine and burnt umber for the next hill forwards, then a stronger mix of the same colours for the nearer hills. The warm colour in the foreground is a reflection of the sky colour.

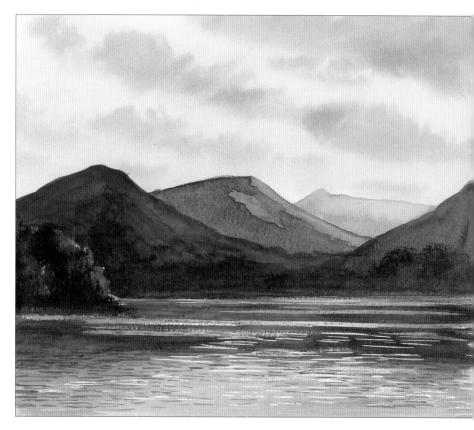

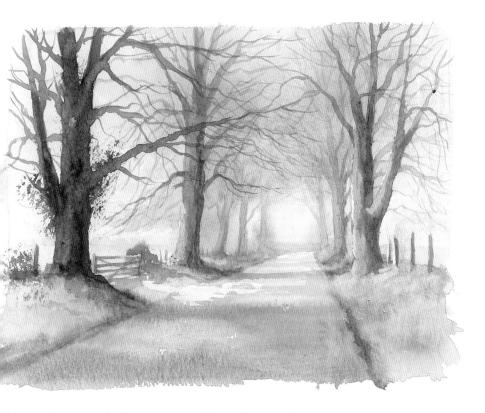

Creating aerial perspective through tone

The overall atmosphere of this painting is cool and misty, but the depth and distance are created by tone. The trees in the far distance are painted with a very pale, watered down mix. By adding more pigment to the mix, I have made the trees in the middle distance stronger and darker. The tree in the foreground is very strong and dark in lone, almost like a silhouette.

PAINTING FIELDS

Note that the colours in distant fields should be paler and bluer, and the fields should be smaller. This will enhance the sense of distance. Add different colours to each individual field to create a patchwork effect.

Simple fields

The hedgerows are created by masking (see page 39).

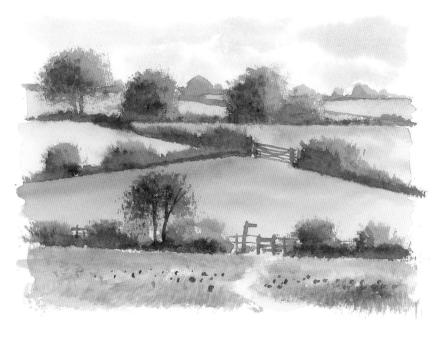

Distant fields

Here I have used the fields to help create a sense of distance in the painting by having the fields in the far distance sma and pale and bluish in tone. The fields in the foreground are much larger and stronger in colour. The fields are painted obliquely, creating a criss-cross shape that leads the eye into the distance, and the farm track also leads into the painting disappearing and reappearing in among the fields. The addition of the buildings establishes the scale of the scene

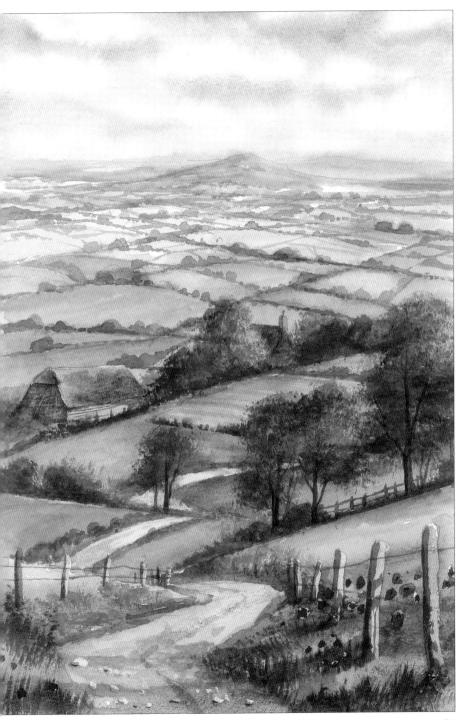

PAINTING TREES

Trees are a vital part of the landscape and interesting trees can make a big difference to a scene. I prefer to create an impression rather than slavishly reproduce every detail, but it is still important to learn how to paint different trees and the way they change with the seasons.

Avoiding brown for tree trunks

One of the most common mistakes when painting trees is painting the trunks brown. They are often either green, silver or grey but rarely brown. Note how the trunk on the right looks much more natural than the brown one on the left.

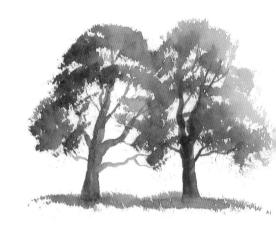

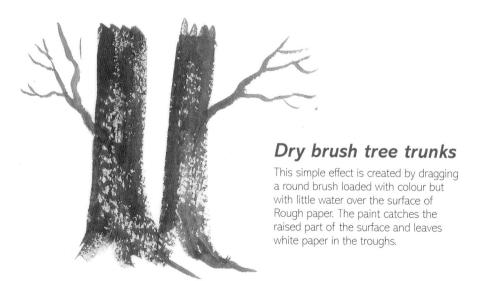

A winter tree

The shape of the tree was stippled with the foliage brush and a light grey mixed from ultramarine and burnt umber. Then the trunk and branches were painted into the shape with the half-rigger and a stronger mix of the same colours.

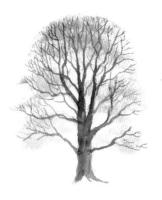

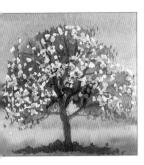

Blossom

The blossom effect was created using masking fluid. For this example I used a small brush and dotted each blossom over the shape of the tree. When dry, I painted the green foliage over the top. When the paint was dry, I removed the masking fluid to reveal the white of the paper. I then painted a pale mix of permanent rose on to some of the blossoms.

A summer oak tree

This was painted using my three ready-made greens: sunlit green was used on the lighter side, then a mix of country olive and midnight green for the shady side, leaving some gaps. The branches and the trunk were added in the same dark green mix, with the branches going through the gaps in the foliage.

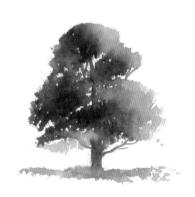

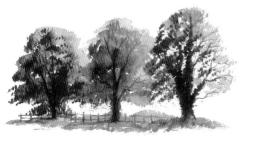

Autumn trees

I have used a selection of earth colours to create the autumn tones, starting with raw sienna for the lighter parts, then burnt sienna for the shaded halves of the trees. The trunks were painted in wet on dry with a dark mix of ultramarine and burnt umber. The ivy was painted in with midnight green.

A conifer

This was painted with the fan gogh brush. Load the brush with the darker colour first and paint from the outside in to the centre. Then load with the lighter colour and paint the other side, again from the outside in. The tree is wider at the base and gradually tapers to a point at the top.

The trunk was painted first, then the foliage was painted with the fan gogh brush. The key is not to have the brush overloaded or too wet, as this will result in a solid wash. Use the very tip of the brush to achieve a streaked effect.

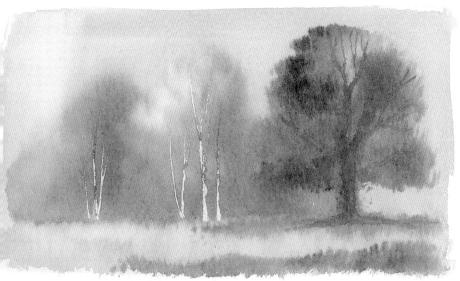

Misty trees

The key to painting misty trees is to use the wet into wet technique. Paint the ky and the background colour in first, and drop the trees in to the wet paint so ne paint dissolves into the background colour. Scrape out the white trunks with ne end of a px (clear acrylic resin) brush handle.

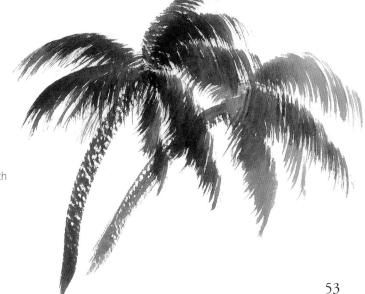

A palm tree

The trunk was painted with large detail brush using he dry brush technique. The fronds were painted with the fan gogh brush with midnight green.

PAINTING GRASSES

When painting grasses, always paint in the direction in which the grass grows: starting from the ground and moving upwards.

Scraping out grasses with a brush handle

 Flick up grasses using the fan gogh brush and a fairly thick mix.

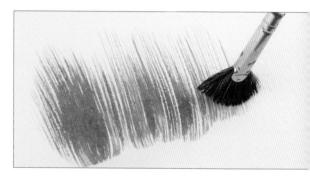

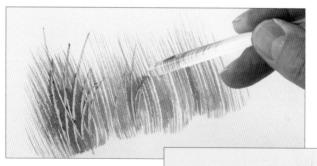

2. Use a clear acrylic resin brush handle to scrape out more grasses from the damp paint. This handle is specially designed for scraping out.

When the paint is dry, you can add darker grasses with a half-rigger brush to complete the effect.

Scraping out grasses

The background colour is blocked in first and before it dries, the grasses are scraped out using the end of a px brush.

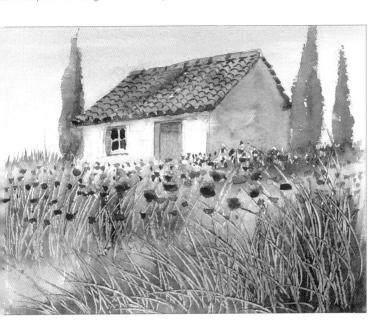

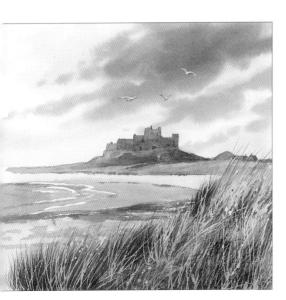

Masking fluid and ruling pen grasses

Apply masking fluid to the paper using a ruling pen. Then paint on a dark colour, making sure your brushstrokes go in the same direction as the masked out grasses. When the paint is dry, remove the masking fluid and wash a pale colour over the white of the exposed paper.

PAINTING FLOWERS

Flowers look best painted freshly on to a white background. This is why masking fluid is often used when painting flowers.

Painting wet-into-wet poppies

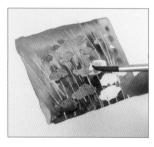

1. Remove the masking fluid ready to paint the poppies. Drop in a fairly pale mix of cadmium red.

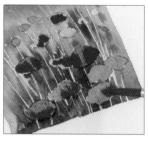

2. While the paint is wet, drop in a thicker mix of cadmium red.

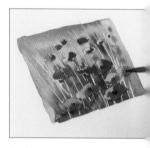

3. Allow the poppies to dry and paint in the centres using shadow colour, a purplish grey. Do not paint centres in all the poppies since some will be facing in a different direction.

Painting finger poppies

1. Paint the poppy shape with a thinner and then a thicker mix of cadmium red as before.

2. Brush in a feathered centre using shadow colour wet into wet.

3. Use your finger to make a fingerprint in the centre.

Painting cow parsley using masking fluid

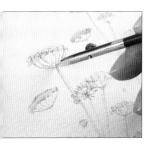

1. Apply masking fluid using a brush for the flowers and a ruling pen for the stalks.

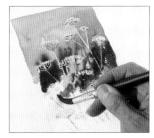

2. Paint a blue sky and various greens wet into wet for grasses.

3. Remove the masking fluid. Paint the stems with a thin mix of sunlit green.

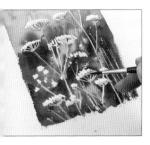

4. Add shade to the white lowers using a very thin mix of raw sienna and cobalt blue and the small detail brush.

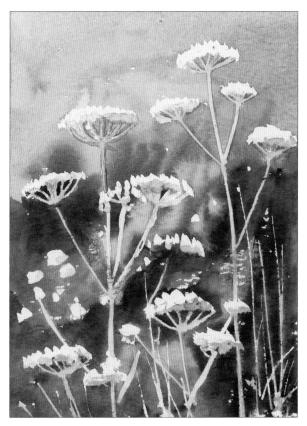

The finished painting.

Painting rhododendrons

The flower heads were stippled first with the foliage brush and permanent rose, then some cobalt blue was stippled on to the underside of the blooms to create the shade. The flowers in the pot were masked off with masking fluid and the colour was dropped in to each individual flower head.

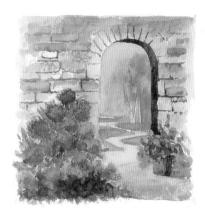

Painting daisies

Daisies need to be drawn and masked off with care. Mask off the daisies and some grasses first, and then paint a green background wash. When that is dry, add some strong, dark brushstrokes to represent grass. When dry, remove the masking fluid. Use cadmium yellow with a hint of cadmium red for the centres of the daisies. Use burnt umber for the shaded edges of the centres. Shade the petals with a very pale wash of cobalt blue. Wash a pale green into the white of the grasses and stems.

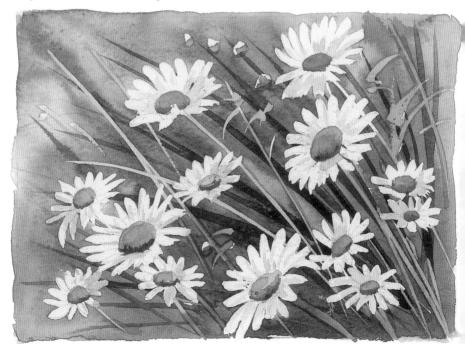

Painting bluebells

The colour mix I use for painting bluebells is simply cobalt blue and permanent rose. By varying this mix, you have a whole variety of tones and shades to create a bluebell wood.

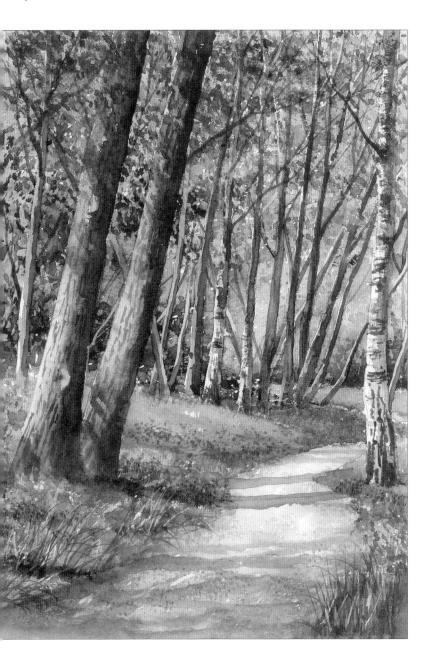

Painting terracotta pots

Terracotta pots will often crop up in paintings, and there are many different ways of painting them. Here are a few examples of colour mixes for terracotta. The same mixes can also be used for painting pan tiles for roofs (see page 79).

burnt sienna and shadow

burnt sienna and raw sienna

cadmium red, cadmium yellow and ultramarine

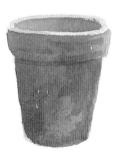

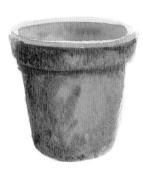

burnt sienna, cadmium yellow and shadow with sunlit green

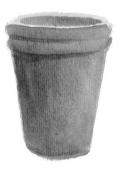

cadmium red, raw sienna and ultramarine

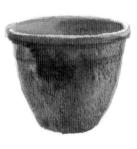

burnt sienna and burnt umber with sunlit green

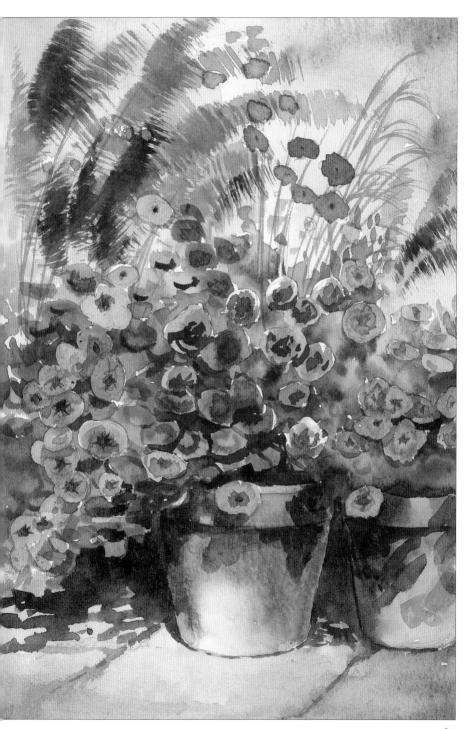

PAINTING MOUNTAINS

When I paint mountains, I try not to put in too much detail as they are often just a backdrop to a painting.

Masking fluid snow

To preserve the white of the snow, I have used masking fluid. A dark cloud behind the mountain creates a contrast. The shade on the snow is created from a pale wash of cobalt blue.

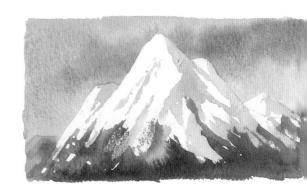

Painting misty mountains

1. Paint the sky and lift out highlights in the clouds.

2. Paint in the mountains using ultramarine and burnt umber, leaving a space for mist as shown.

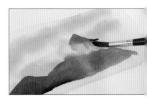

3. Allow the mountains to dry. Wet the misty area with clean water.

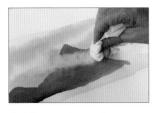

4. Lift out colour using kitchen paper.

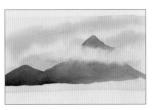

The finished misty mountains.

Scraping out mountains with a plastic card

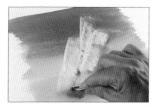

2. Take a plastic card such as an old credit card and scrape mountain shapes into the wet paint.

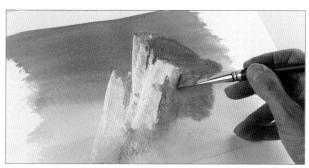

Dropping in raw sienna

Naw sienna has a tendency to repel other colours when mixed vet into wet. This can create a useful effect.

1. Paint the mountain shape using a mix of shadow colour and burnt umber.

 While the paint is still wet, drop in raw sienna to one side. The raw sienna pushes away the darker paint to create the effect of sunlit rock.

PAINTING WATER

Painting water is one of the biggest challenges for any artist. Water has many moods and many different forms, such as rivers, seas, ponds and dramatic waterfalls.

Painting a waterfall

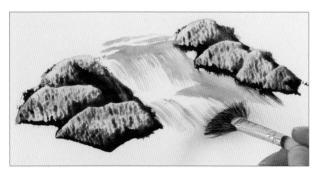

1. Paint the rocks first, then pick up cobalt blue mixed with midnight green on the fan gogh brush. Paint ripples at the top of the waterfall and then drag the brush down the path of the water.

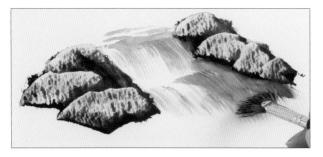

2. Allow the paint to dry, then mix cobalt blue with ultramarine and burnt umber and darken the water's edge beneath the right-hand rocks.

A masking fluid waterfall

arefully plan and draw the flow of the river. Mask off the foamy white water with masking fluid, painting in the direction in which the water flows. Paint the bocks in a dark colour for contrast. Use cobalt blue with a touch of midnight reen to paint in the mid-tone of the water. Remove the masking fluid and efine the detail of the water with the same mix.

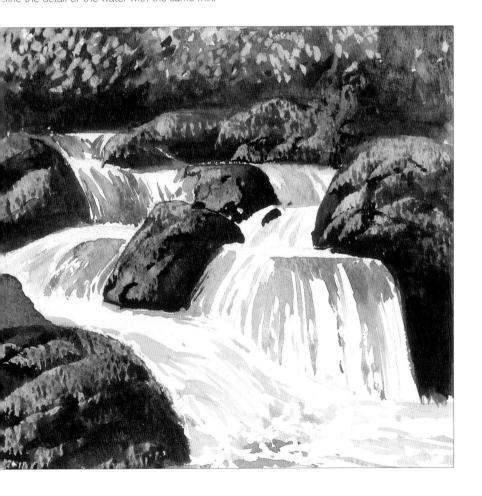

Masking fluid ripples

Masking fluid is used to capture the sunlight on the water. The ripples in the far distance are painted in first with small horizontal brushstrokes. These become broader and larger as they reach the foreground.

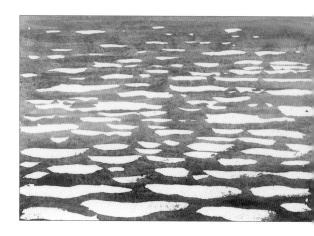

Lifting out ripples

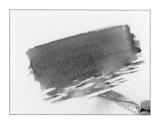

1. Take the 19mm (¾in) flat brush and paint a flat wash for the water. Towards the bottom, move the brush from side to side to create a rippled effect.

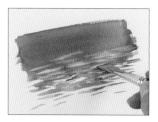

2. Before the paint dries, wash the brush, squeeze out the excess water and lift out ripples from the wet wash.

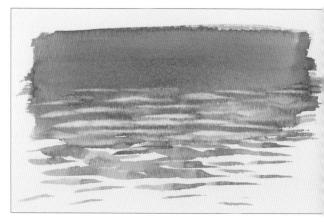

The finished water.

Dragging down reflections

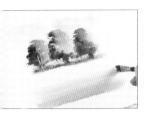

. Wet the water area with lean water and the wizard rush. Paint a thin wash of lltramarine from the bottom. The water on the paper neans that the wash will fade awards the top.

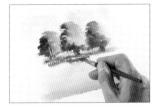

2. Paint reflections of the bank colours and drag them down slightly into the water, working wet into wet.

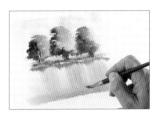

3. Pick up the lighter tree colours and drag them down into the water as before, wet into wet.

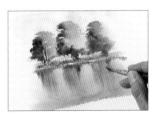

4. While the paint is still wet, drag darker greens down into the water to reflect the trees and other details above.

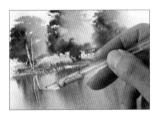

5. Use the handle end of a px brush to scrape out the reflection of the left-hand tree trunk.

he finished scene.

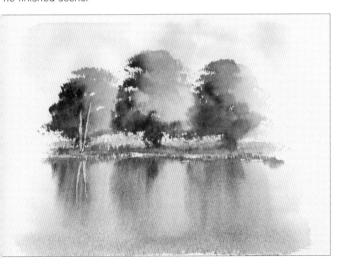

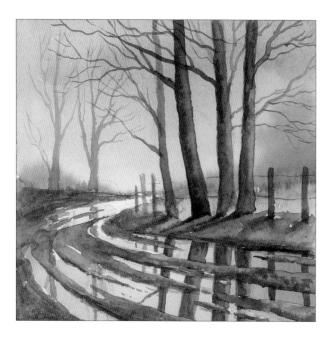

Reflections of posts and trees

If you are painting puddles in a road, always paint reflections in them. This tells the viewer that it is water. Be sure to observe the scene or reference photograph carefully so that you get the angles of posts and trees right.

Breaking waves

I have relied heavily on using masking fluid for the white foam in this painting. The movement of the wave hitting the rock is exaggerated by flicking up the masking fluid to represent spray. This adds drama to a painting.

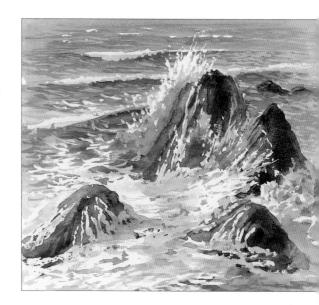

Painting choppy water

I. Paint a background ultramarine wash and let it dry. Use the 19mm (¾in) lat brush to paint diagonal strokes with a stronger mix of ultramarine.

2. As you come towards the foreground, use a strong mix of ultramarine and midnight green and make bigger marks.

The finished scene.

Using masking tape to paint a straight horizon

Before using masking tape, rub the sticky side with your fingers or apply it first to your clothes. This makes it less tacky and less likely to pull off paint when removed.

1. Paint the sky first, let it dry and then apply masking tape in a straight line at the bottom, with the bottom of the tape where you want the horizon to be.

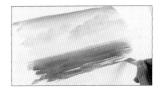

2. Use the 19mm (¾in) flat brush to paint the sea, going over the bottom of the masking tape.

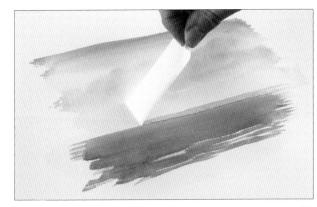

 When the paint is dry, peel off the masking tape, making sure you pull it upwards, away from the horizon line.

Using a sponge to lift out spray

The tip for this technique is speed. As soon as the paint is applied, the spray is lifted off the paper with a damp sponge. When the painting is dry, the detail is added.

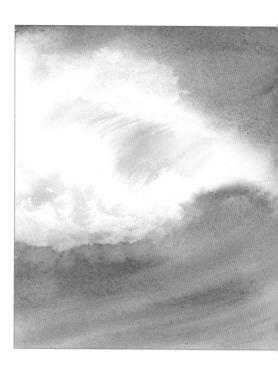

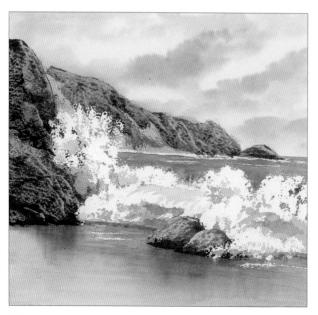

Masking fluid spray

This was done by applying masking fluid with a natural sponge. You can also use screwed up kitchen paper. The shade on the spray was painted in with cobalt blue and a touch of permanent rose.

Cliffs reflected on a beach

Plask off the surf lines first, and paint the sky. Paint the cliff using the rock painting echniques shown on page 74, then wet the whole sea area. Drag the cliff colours ertically down to create reflections on the beach, then merge them into blue on the eft-hand side to reflect the sky. Remove the masking fluid and touch in a light blue or the detail on the surf lines.

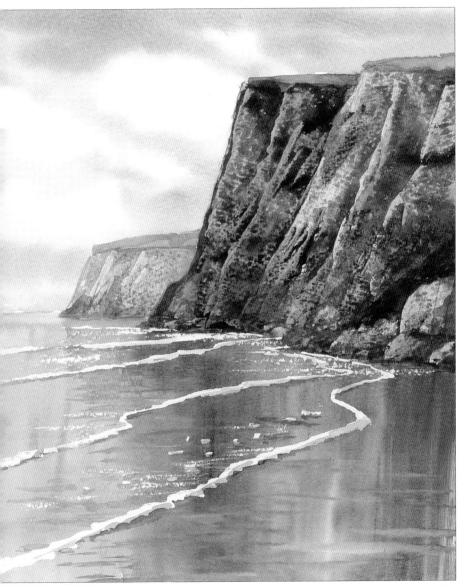

PAINTING BEACHES

A lot of emphasis is placed on painting water, but the shoreline and beaches are often neglected. Here are a few tips on how to tackle these foregrounds.

Sand

The colour I have used for the sand is mostly raw sienna. I have added some shadow colour in amongst the sand dunes for shade.

Stippling pebbles

The background colour was washed in with raw sienna, then with a stronger mix of raw sienna, and the pebbles were stippled using the foliage brush. Finally some shade was added to the undersides of the pebbles in the foreground to create form.

Spattering pebbles with masking fluid

To apply the masking fluid I used a stiff-haired toothbrush. Then some larger pebbles were dotted in with masking fluid applied with a small round brush. When the masking fluid was dry, I painted in the background colour. When dry, I removed the masking fluid and washed a light colour over the stones. I finished off with some shade underneath the larger stones.

A masking fluid surf line

You can paint in surf lines and ripples with masking fluid. Paint the beach n with raw sienna, then wash the blue down into the raw sienna while t is still wet. Remove the masking fluid, then paint in the darker detail underneath the surf lines and the darker ripples.

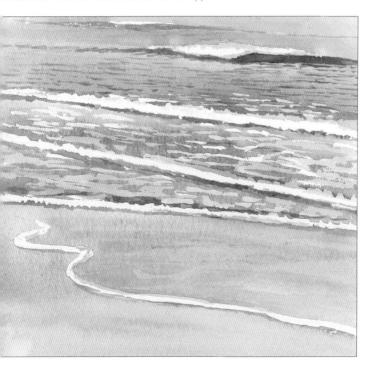

PAINTING ROCKS

Rocks have varied surfaces and colours: warm sandstone contrasts with hard, cool granite, so your choice of colours is as important as creating texture.

Credit card rocks

The surface of the paper will create the textured effect so choosing the right paper is important. Choose Rough paper for this technique.

1. Take a stiff-haired brush such as the fan stippler and apply the lightest colour, raw sienna, first. The mix should be very thick. Add country green for moss.

2. Paint thick ultramarine and burnt umber on top.

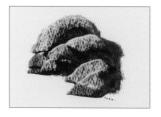

 Scrape an old credit card or other plastic card over the surface to remove paint to create rock shapes. Start with the furthest rocks and come forwards.

The finished rocks.

Foliage brush rocks

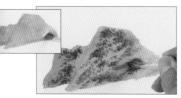

1. Paint on a thick mix of raw sienna with a little ultramarine, then stipple on texture using the foliage brush and burnt umber mixed with ultramarine.

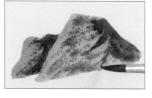

2. Use a round brush to paint on a darker shade of the same mix to create shadows.

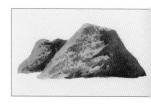

The finished rocks.

PAINTING CLIFFS

Whatever cliff you are painting, whether chalk or hard stone, the choices remain the same, those of colour and texture

White cliffs

The technique used here is the dry brush method, dragging the almost dry brush lightly over the surface of the paper, leaving the paint on the raised part of the paper and the white remaining in the dips.

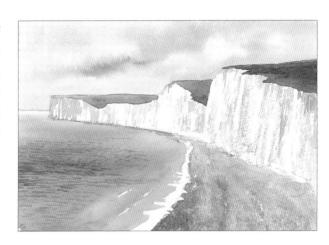

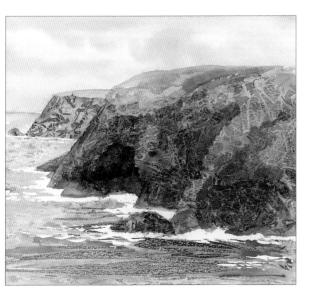

Cling film cliffs

This is a relatively simple way to create texture using cling film. Mix plenty of colour, in this case ultramarine and burnt umber, then paint it on to the surface of the cliff face. While it is still wet, scrunch up cling film and press it on to the surface of the painting. Allow this to dry naturally. Once dry, remove the cling film to reveal a beautiful, natural-looking texture.

PAINTING BOATS

It is a shame that timid artists shy away from painting boats, as they can add something special to a scene.

Boats with character

Choose something with character; avoid plastic boats. If the boat you wish to paint is plastic, why not change it into something more rustic.

The waterline

Use dark colours along the waterline. This gives the impression that the boat is sitting in water rather than on it.

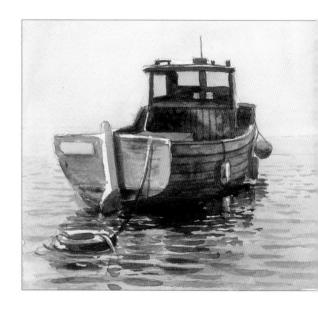

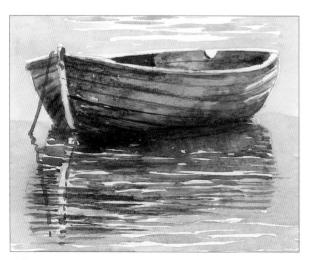

Conceal the inside

Make sure you do not reveal too much of the inside of the boat, or this will give the impression that the boat is tilting forwards.

PAINTING ROOFS

Painting roofs can get quite technical. There is a whole variety of materials used for roofing, so time should be spent establishing what material the roof is made of. Roofs can be tackled in so many different ways.

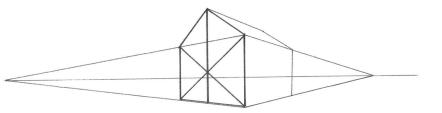

How to find the correct pitch of any roof

Begin by drawing a rectangle, which is the front of the building. If you join each corner diagonally (making a cross), the centre of the cross is the centre of the building. Draw a vertical line through the centre of the cross to the top of the roof (the height will obviously vary). Whatever height you choose to make the roof, you join the top two corners of the building to create the apex of the roof. I know this sounds complicated, but once you have a go it all makes complete sense.

A slate roof

The most distinctive thing about a slate roof is the colour. Depending on the lighting conditions, the roof can appear warm or cool but it will always be grey.

In this example I have used a combination of raw umber with raw sienna and some green dropped into the paint when it was still wet.

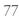

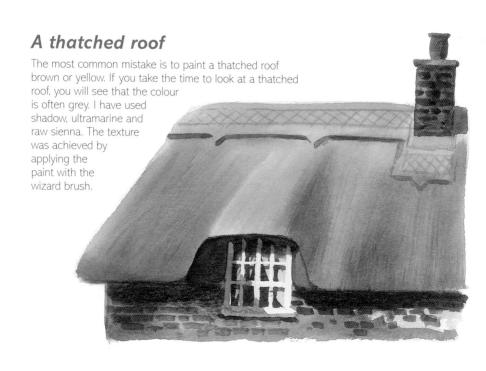

A clay tiled roof

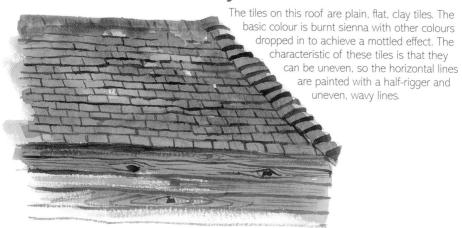

A tin roof

Vhen painting corrugated tin oofs, it is important to give ne impression of uniform corrugation. Do not paint his too loosely: the letailed lines must be evenly spaced and ne edge of the tin panels will have a wavy, ineven edge.

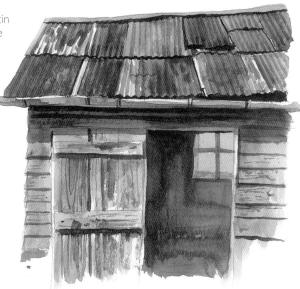

Pan tiles

here are two things to consider: colour and the distinctive pattern. The colours are bright and varied (see the mixes or terracotta pots on page 60). The vertical tile ridges are evenly spaced and each tile is painted with a semi-circle, arrowing towards the top of the roof. Tiles in the gully are eversed like a smile shape.

PAINTING WALLS

Materials used in building houses are many and varied. Painting them is mostly about suggesting textures: for example those of flints, stone or plaster.

Scraping out to create dry stone walls

1. Use the foliage brush to paint on a thick mix of raw sienna, followed by one of sunlit green on top.

2. Make a thick mix of ultramarine and burnt umber and stipple this on top.

3. Use the end of a px (clear acrylic resin) brush handle to scrape out shapes for stones.

The finished wall. The scraping out technique removes part of the dark top layer of paint to reveal the lighter colours underneath.

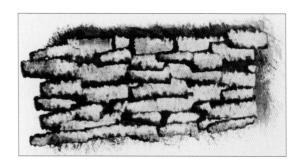

Another dry stone wall

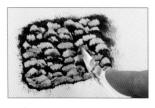

Apply the lighter colours first, and then a dark brown mix on top, as before. Use the brush handle to scrape out rounder, more irregular shapes to imply stones.

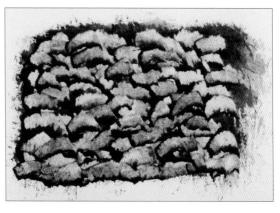

A flint wall

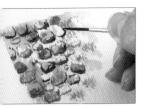

aint in a background wash nd let it dry. Stipple on exture in various colours sing the foliage brush. Use ne half-rigger and a dark nix to pick out the shadows ound stones, suggesting regular, rounded shapes.

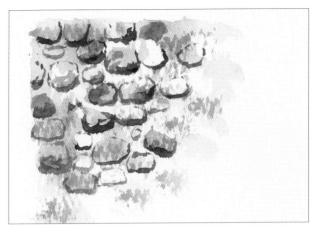

The finished flint wall.

A red brick wall

aint a pale background first and allow it to dry. Then use the ledium detail brush to paint bricks with one stroke for each. It is wet, drop in other colours for variation.

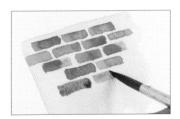

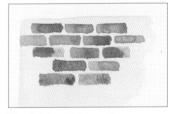

The finished brick wall.

A rustic stone wall

aint the background and low it to dry. Stipple on exture using the foliage rush, then paint in a dark hadow under each stone sing the half-rigger.

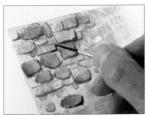

A detailed stone wall

The texture and detail can be enhanced by using some white gouache.

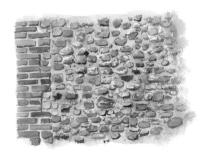

A detailed brick wall

To make the bricks appear threedimensional, paint a thin, dark shadow on the underside of each brick.

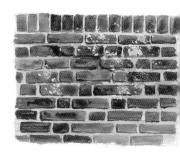

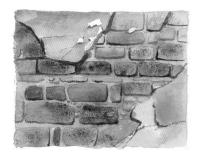

A rustic wall with peeling plaster

Although this is a very rustic wall, the bricks and stones are carefully painted to avoid the vertical joints lining up. So the rules for painting a brick or stone wall are the same as for building one!

A plastered wall

To add texture to what would appear to be a flat surface, some of the plaster could be removed to reveal stonework underneath. A dark shadow is then placed on the underside of the plaster to give the impression that the plaster sits on top of the brick.

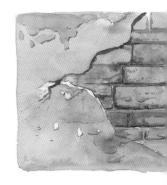

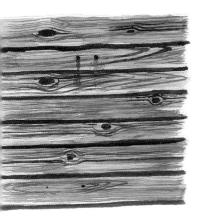

Weatherboards

To give the impression of the overlap, a dark line is needed, and this line could be painted with a slight wobble for a weathered look. The horizontal wood grain was painted using the wizard and the detail of the knots enhanced with a half-rigger.

orkshire stone

he dominant colour of the conework is grey, which is a ambination of burnt umber and ultramarine, but adding ther colours such as burnt enna, raw sienna and various reens creates a more mellow opearance. The detail is ainted with the half-rigger.

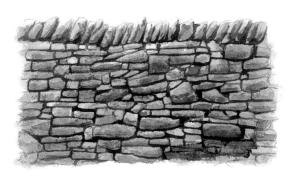

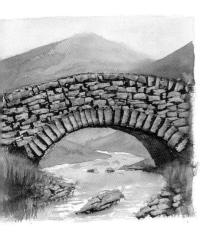

A bridge

This technique is exactly the same as the scraping out technique for walls described on page 80. The arch of the bridge is created by scraping vertical blocks downwards, following the curve of the arch. A shadow is then placed underneath.

PAINTING WINDOWS

Windows are often neglected as part of a building, but they can add so much character to a painting.

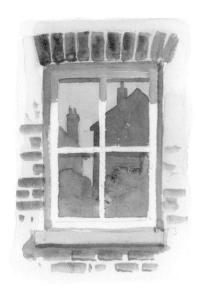

Reflections

When you look at a window from the outside, you do not always see a black hole: what you see are reflections on the glass. These are often reflections of trees or buildings behind you. When you are painting a reflected building, create a simple roof and chimney silhouette and avoid any details.

Lighted windows

To make a painting interesting, you could choose to paint the subject at dusk or at night. The lighted window should always be the lightest part of the painting. A good idea to create this effect is to apply a pale wash of colour over the entire picture, leaving the lighted window unpainted. Later you can add a warm yellow to the lighted area to introduce some colour. The window frames should be painted dark over a light background.

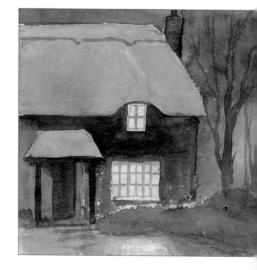

Net curtains

The window frames of this painting were first painted with masking fluid and some candle wax was applied to the textured part of the net curtains. Then a light grey wash was applied over the windowpanes, allowing the paint on the wax to create the texture of the net. When this was ry, the masking fluid was removed to reveal the window frame.

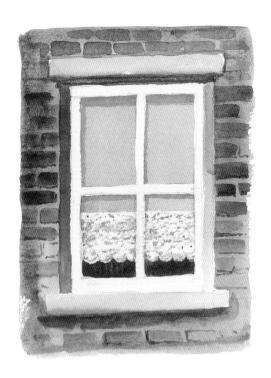

Shutters

A great subject for a painting is a sunlit, shuttered window. An added bonus is a brightly coloured window box. With this example I used masking fluid on the window frames and also the flower heads, but look closely at the inside of the window: the folds of the curtains are carefully painted in over the masking fluid, and a deep shadow is added on the top half of the curtains. This adds depth to the painting. Do not forget to put shadows under the shutters and also the flowers.

PAINTING DOORS

A doorway can be a fascinating subject for a painting. There are so many different types, ranging from smart and sophisticated to rustic and quaint. My favourite doorways to paint would fall into the rustic category, mostly because they are easier to paint.

An open door

To make this painting tell a story, I have left the door ajar. Having the door slightly open leads you into the painting and leaves the viewer wondering what lies beyond. To add extra colour and interest to the painting I have placed some flowerpots in the foreground.

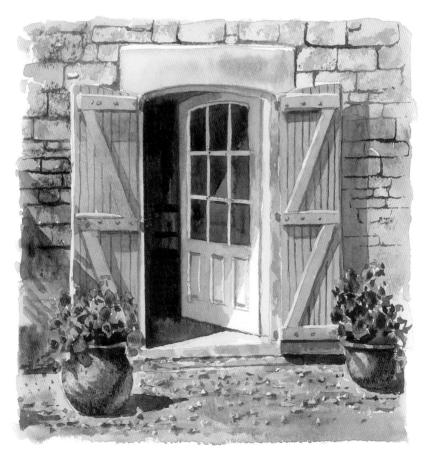

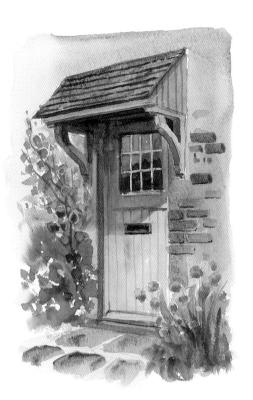

A porch

A doorway can be made more elaborate by the addition of a porch. The most common fault with painting these is not leaving enough room at the top of the door. The porch must be either the same height or taller than the door to allow someone to walk under it. Porches are very common on quaint cottages and can be enhanced with the addition of some roses round the doorway. A little bit corny, but why not?

A rustic door

When you look at some doors, you can tell straight away that they are ancient. They might be an original feature of the building, and how nice it is to see these have not been replaced with a modern alternative. To make this door look weathered and old, I have made the top and bottom of the door uneven, removed some of the wood panels to reveal the dark gap and painted the door panels with an uneven and knotted texture. Using the wizard brush creates the wood grain effect. The top hinge was painted at a slight angle with rust stains around the metalwork.

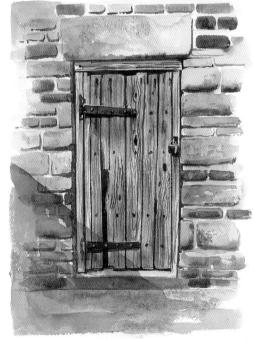

STILES, GATES AND FENCES

When painting landscapes, you can introduce some man-made objects that will help to enhance the natural features.

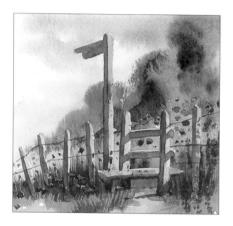

A stile

One of my favourite subjects to paint is a country stile. It is not a complicated structure and there are so many different varieties to choose from. One thing to remember when painting a stile is that it is a means of climbing over a fence and the reason for the fence is to keep animals in a field, so don't forget to complete the fence!

A five-bar gate

I have been told in the past that you can tell the region of the country by the style of a gate, but I think nowadays, anything goes.

The gate in this painting is what I would call a typical five-bar gate. I have used masking fluid for the left-hand side so when the painting is complete, the right-hand side is dark against light and the left-hand side is in sunlight, light against dark. Leaving the gate ajar will lead you into the painting. (You should always follow the country code and keep gates

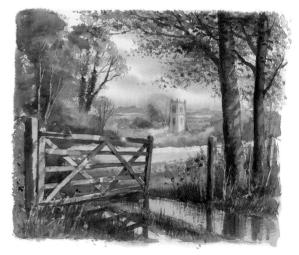

Adding a fence and other details

A painting can be greatly improved by the addition of a fence, stile and signpost.

. When the painting is dry, waint a stile using a half-rigger and a mix of country olive and wurnt umber.

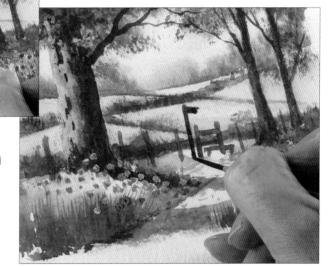

2. Paint in a fence in the same way and add a signpost.

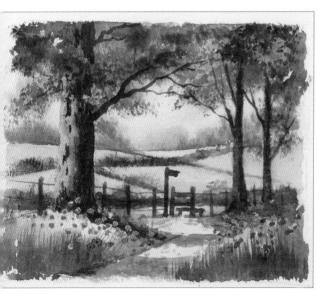

3. Brush in the fence horizontals to finish the scene.

WINTER SCENES

Painting snow on white paper is obviously going to create a challenge; I rely heavily on masking fluid to help me achieve the effects I want.

Colours for snow shadows

The colours for snow shadows can vary, but often use cobalt blue mixed with a little shadow colour. This gives me the desired effect, but depending on the lighting effects, these colours can change, so a variety of blues could be used. The important thing to remember is to avoid using grey.

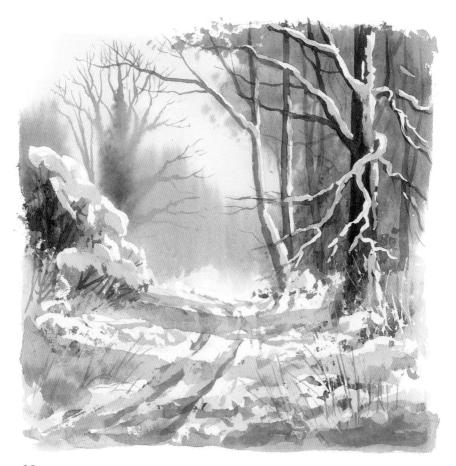

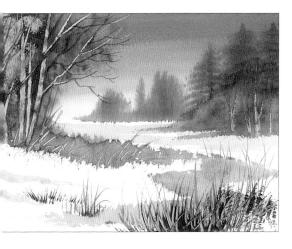

Grass growing through snow

To help break up a large area of white foreground, grass can be painted in with the fan gogh brush or a half-rigger. Another tip is to use a px (clear acrylic resin) brush handle to scrape out some grasses whilst the paint is still wet. This technique was also used to scrape out the tree trunks on the left.

Textures in snow

An interesting effect can be achieved by sprinkling grains of salt on to wet paint. The salt absorbs the paint, leaving a starburst shape, which is ideal for suggesting snowflakes and frost. To get the best results from this technique, allow the paint to dry icompletely and in its own time (do not use a hairdryer), then dust off the salt particles.

Masking fluid snow on trees

Masking fluid can be used to great effect when painting snow. Here I applied the masking fluid with a sponge for the treetops, and with a small brush for the snow that had settled on the branches and trunks. I used a ruling pen to apply the masking fluid to the fence and the grasses in the foreground. Some of the ruts and texture in the foreground were painted with masking fluid. After removing the masking fluid, a light wash of cobalt blue was applied to create some shadows, leaving the rest as white paper.

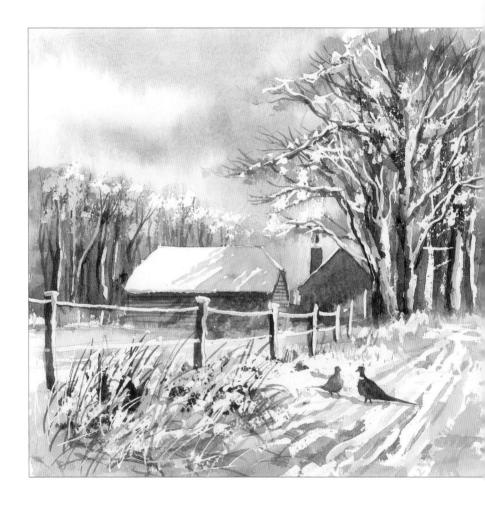

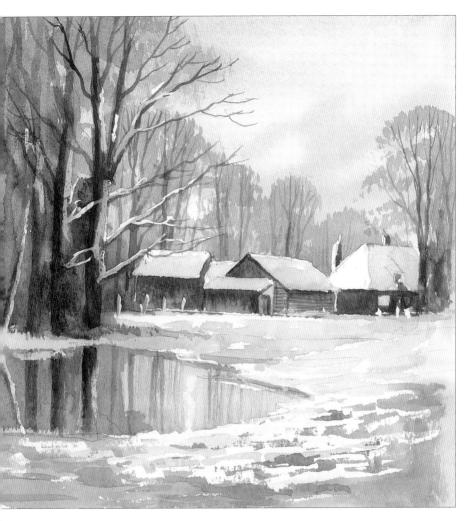

Warming up a snow scene

snow scene does not necessarily have to be cold, frosty and unpleasant. If you paint a scene at sunset, this gives you the opportunity to introduce a whole yariety of warm colours. Here I applied masking fluid in the same way as in the other examples, but I added the colours of the sunset reflected in the snow.

ADDING LIFE

Simply adding a living creature to a painting can enhance it a great deal as it begins to tell a story rather than just being a pleasant view.

Figures

This is a simple painting of two boats, but adding the figures makes it a different type of painting. By having two figures you are adding a conversation to the painting. It is a good tip to leave something to the imagination of the viewer.

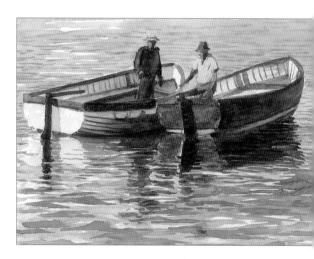

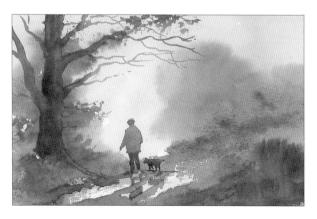

A man and a dog

This painting would be very simple and almost uninteresting without the man and his dog, but adding them has created something a lot more substantial.

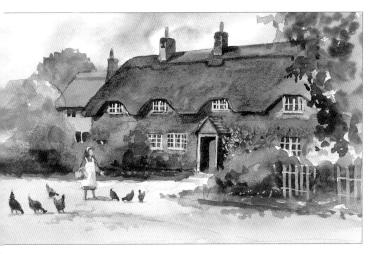

Cottage with chickens

his charming painting of a thatched cottage is brought to life simply by dding a few chickens and the farmer's daughter. Without these added lements, the painting would merely be a building study.

3irds

What makes a sunset painting interesting is usually not the actual sunset, but the cene it affects, for example the sun setting over an estuary, the silhouette of a proup of trees or the outline of a windmill. If we have a sunset on its own with o landscape and we add a flock of birds, it becomes a painting in its own right.

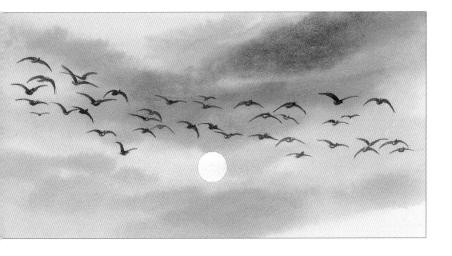

INDEX

aerial perspective 46, 47

beach(es) 71, 72–73 boats 76, 94 bridge 25, 83 brushes 6, 8, 12–15, 16, 20, 36 px 12, 53, 55, 67, 80, 91 buildings 12, 25, 48, 77, 84, 87, 95

'cauliflowers' 20, 30, 34, 35 cliffs 6, 21, 71, 75 cloud 30, 31, 34, 35, 43, 62 credit card 63, 74

doors 86–87 dry brush technique 11, 32, 50, 53, 75

fence 37, 88–89, 92 fields 39, 48 flowers 12, 22, 56–61, 85 foliage 12, 41, 51, 52

gate 88–89 grasses 12, 20, 27, 37, 54–55, 57, 58, 91, 92

hard lines 34, 35 hedgerows 39, 48 highlights 43, 62 horizon 42, 69

landscape 11, 42, 50, 88, 95 lift(ing) out 20, 40, 43, 45, 62, 66, 70

masking fluid 10, 20, 21, 36, 37, 38, 51, 55, 56, 57,

58, 62, 65, 66, 68, 70, 71, 73, 85, 88, 90, 92, 93 mountains 21, 62–63

paint consistency 26, 28
painting water 12, 64–71, 72
paints 6, 16–19
tube 16, 19
palette 18, 19, 20, 22, 26, 27, 28, 29
paper 8, 10, 11, 21, 27, 35, 36, 38, 39, 50, 55, 67, 74, 75, 90, 92
Rough 11, 32, 50
surface 8, 10, 11, 36, 50, 74, 75
photograph 24, 25, 68
plastic card 21, 63, 74

reflections 12, 67, 68, 71, 84 ripples 12, 64, 65, 73 rocks 21, 38, 63, 64, 65, 68, 71, 74 roofs 60, 77–79, 84 ruling pen 20, 37, 55, 92

scraping/scrape out 12, 53, 54, 55, 63, 80, 83, 91

sea 38, 71 sky/skies 12, 30, 31, 42–45, 46, 53, 57, 62, 69, 71 snow 62, 90, 91, 92, 93 stile 88–89 sunset 10, 42, 45, 93, 95

terracotta 60, 79 texture 10, 12, 21, 32, 74, 75, 81, 85, 87, 91, 92 trees 12, 21, 38, 40, 41, 42, 47, 50–53, 67, 68, 84, 91, 92, 95 branches 41, 51, 92 trunks 21, 32, 40, 41, 50 51, 52, 67, 91, 92

walls 12, 80–83
wash(es) 10, 11, 12, 17,
28–29, 30, 31, 32, 33, 34,
42, 43, 46, 52, 58, 62, 66,
67, 69, 81, 84, 85
waterfall 64, 65
wet into wet 8, 30–31, 32,
33, 34, 35, 42, 53, 56, 57,
63, 67
wet on dry 32–33
window 84–85
winter scene 10, 90–93

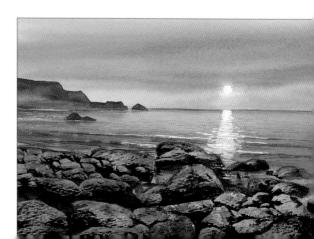